This book belongs to

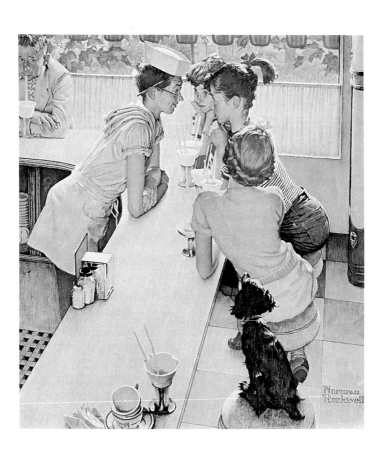

Norman Rockwell's
American Memories

MJF BOOKS

NEW YORK

Frontispiece: AT THE SODA FOUNTAIN
Saturday Evening Post cover, August 22, 1953

Published by MJF Books
Fine Communications
Two Lincoln Square
60 West 66th Street
New York, NY 10023

Norman Rockwell's American Memories
Library of Congress Catalog Card Number 99-74468
ISBN 1-56731-352-3

This volume includes three books formerly published as *American Memories-Norman Rockwell, Wit and Humor of Norman Rockwell,* and *An American Family Album-Norman Rockwell,* all copyright © 1993 by Armand Eisen.

Printed in Singapore on acid-free paper

MJF Books and the MJF colophon are trademarks of Fine Creative Media, Inc.

10 9 8 7 6 5 4 3 2 1

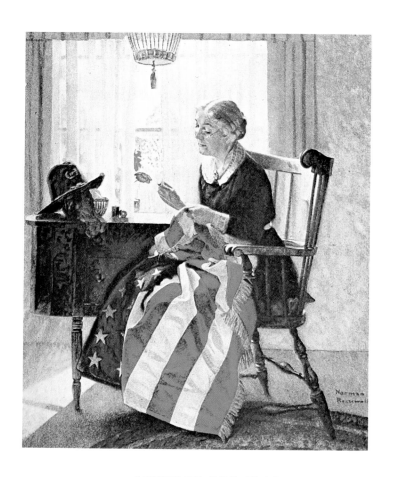

MENDING THE FLAG

Literary Digest cover
May 27, 1922

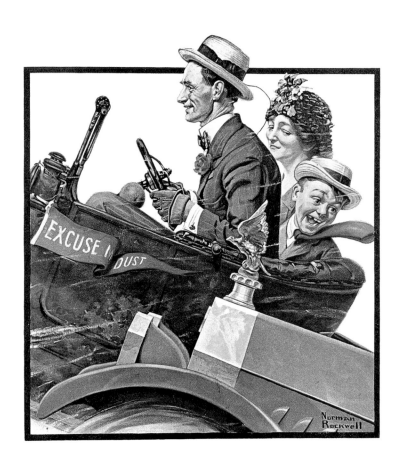

THE OPEN ROAD

Saturday Evening Post cover
July 31, 1920

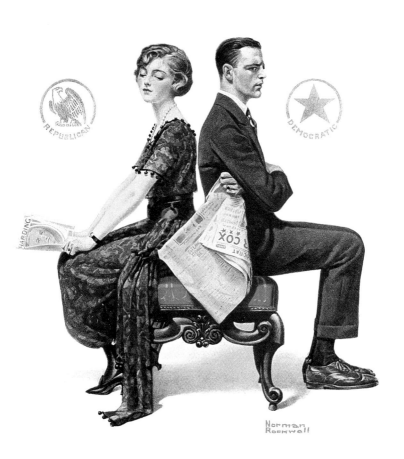

THE DEBATE

Saturday Evening Post cover
October 9, 1920

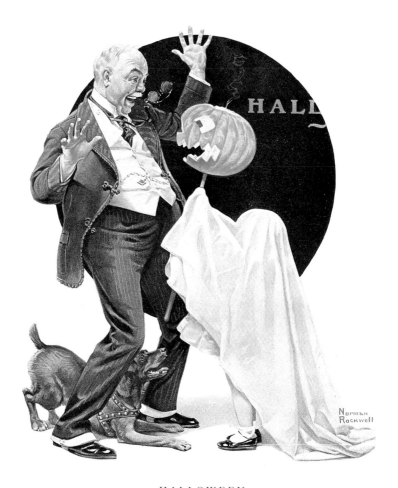

HALLOWEEN

Saturday Evening Post cover
October 23, 1920

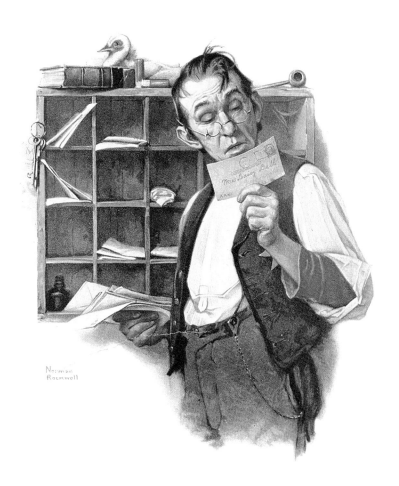

POSTCARD

———

Saturday Evening Post cover
February 18, 1922

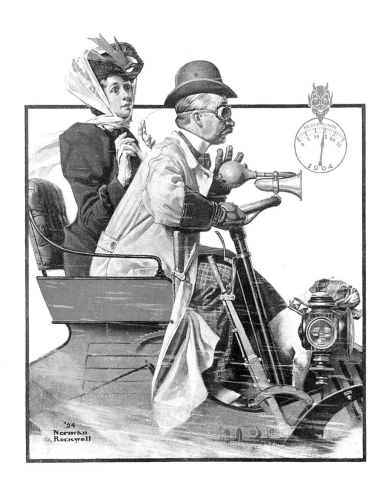

SPEED

Saturday Evening Post cover
July 19, 1924

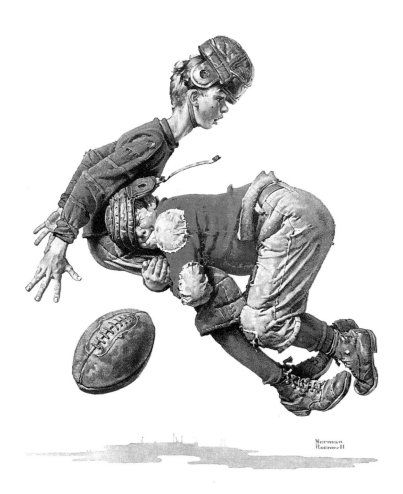

THE TACKLE

Saturday Evening Post cover
November 21, 1925

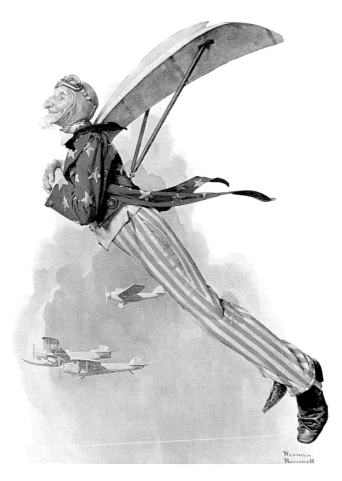

UNCLE SAM TAKES WING

———

Saturday Evening Post cover
January 21, 1928

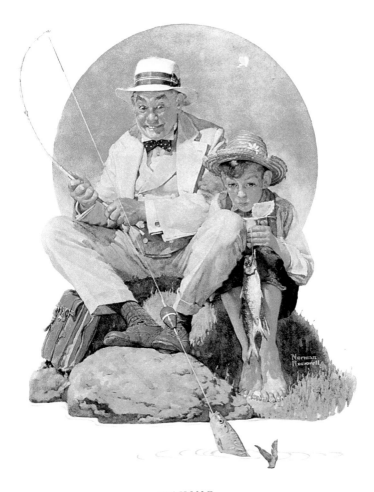

FISHING

Saturday Evening Post cover
August 3, 1929

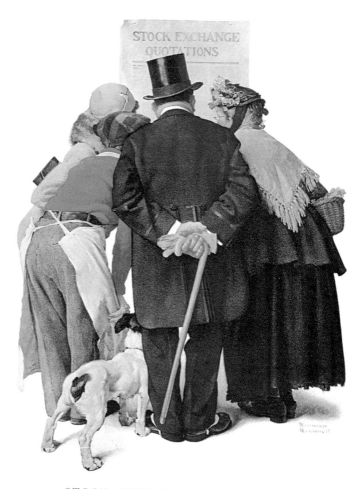

STOCK EXCHANGE QUOTATIONS

Saturday Evening Post cover
January 18, 1930

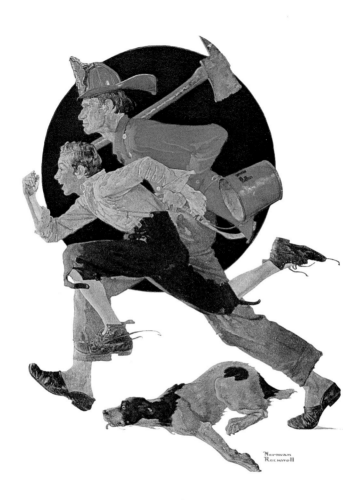

FIRE!

Saturday Evening Post cover
March 28, 1931

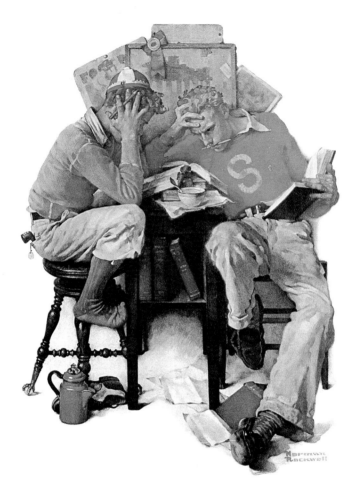

CRAMMING

Saturday Evening Post cover
June 13, 1931

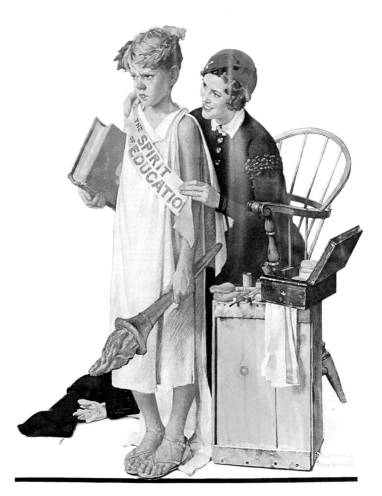

THE SPIRIT OF EDUCATION

Saturday Evening Post cover
April 21, 1934

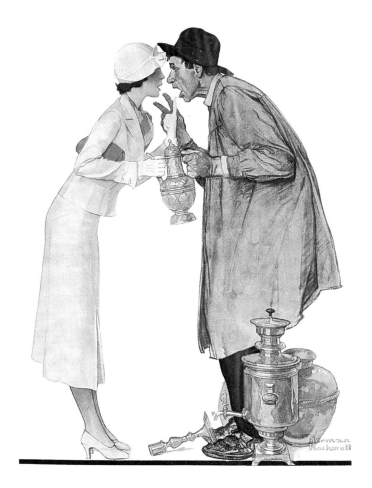

STRIKING A BARGAIN

Saturday Evening Post cover
May 19, 1934

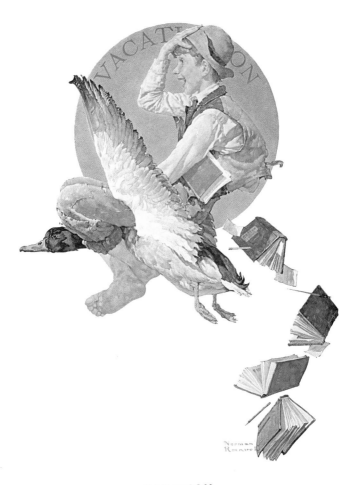

VACATION

Saturday Evening Post cover
June 30, 1934

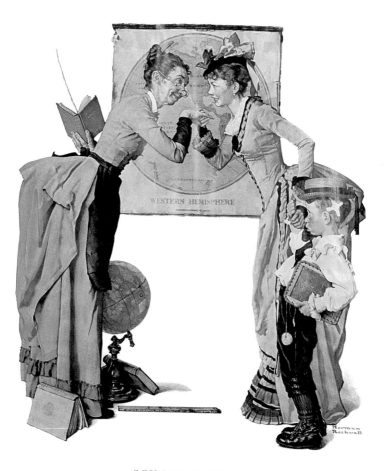

SCHOOL DAYS

Saturday Evening Post cover
September 14, 1935

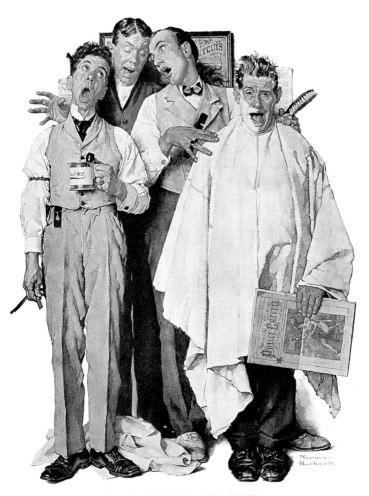

BARBERSHOP QUARTET

Saturday Evening Post cover
September 26, 1936

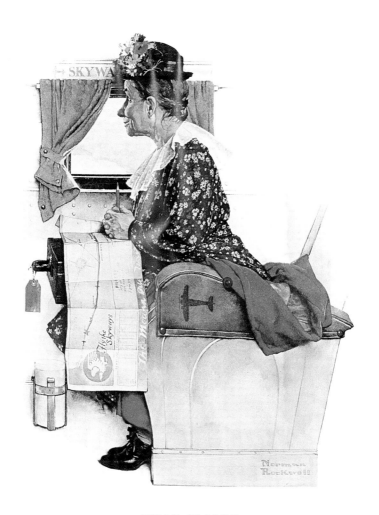

FIRST FLIGHT

—

Saturday Evening Post cover
June 4, 1938

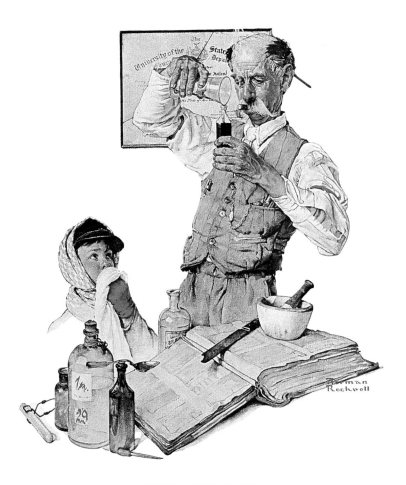

THE DRUGGIST

Saturday Evening Post cover
March 18, 1939

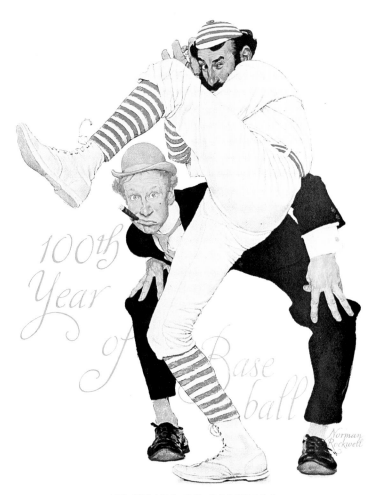

100 YEARS OF BASEBALL

—

Saturday Evening Post cover
July 8, 1939

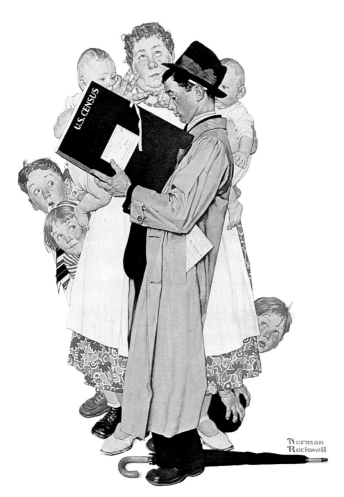

CENSUS TAKER

Saturday Evening Post cover
April 27, 1940

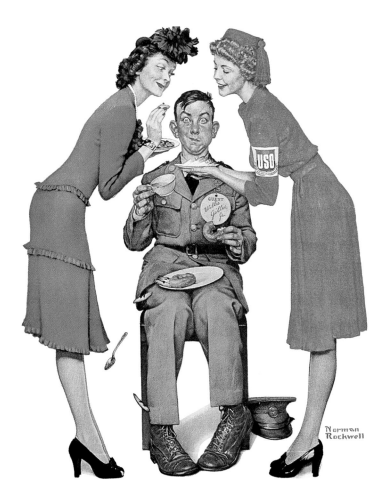

USO VOLUNTEERS

Saturday Evening Post cover
February 7, 1942

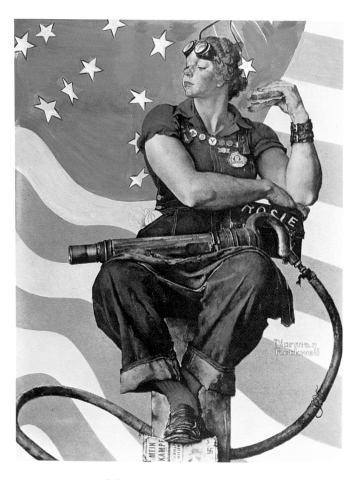

ROSIE THE RIVETER

Saturday Evening Post cover
May 29, 1943

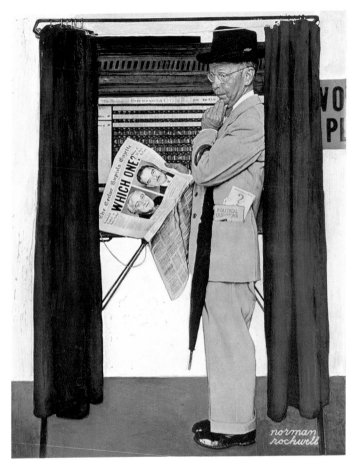

WHICH ONE?

———

Saturday Evening Post cover
November 4, 1944

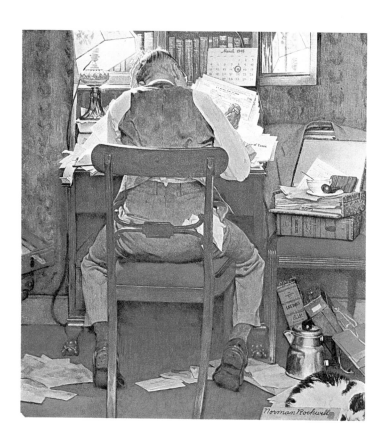

TAXES

Saturday Evening Post cover
March 17, 1945

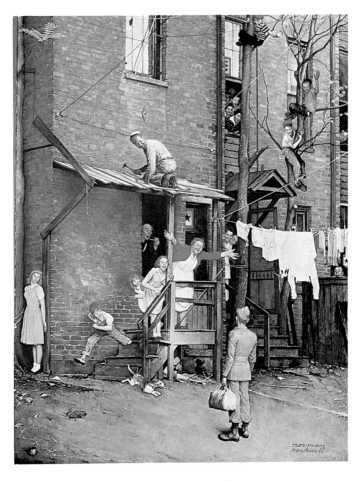

HAPPY HOMECOMING

Saturday Evening Post cover
May 26, 1945

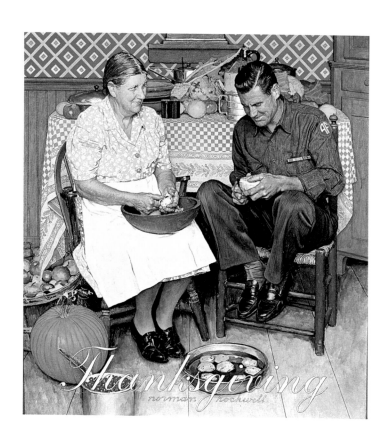

THANKSGIVING

Saturday Evening Post cover
November 24, 1945

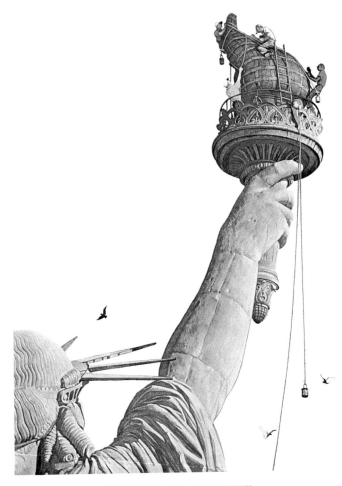

STATUE OF LIBERTY

Saturday Evening Post cover
July 6, 1946

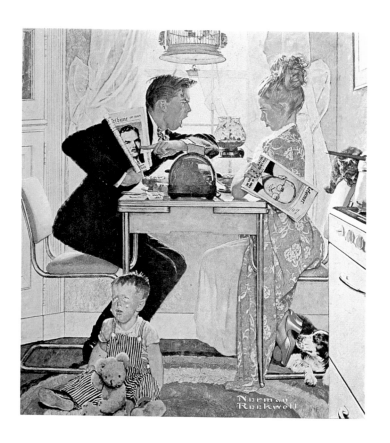

ELECTION DAY

—

Saturday Evening Post cover
October 30, 1948

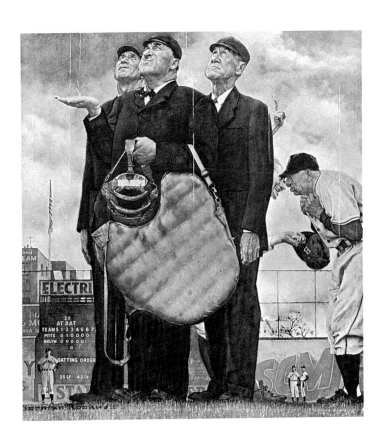

BOTTOM OF THE SIXTH

Saturday Evening Post cover
April 23, 1949

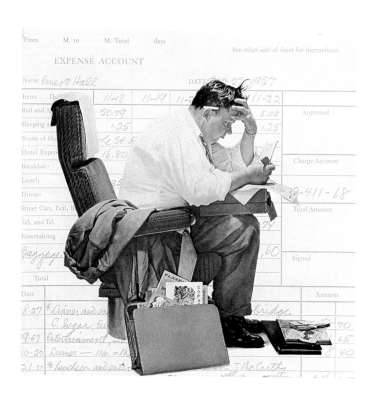

EXPENSES

Saturday Evening Post cover
November 30, 1957

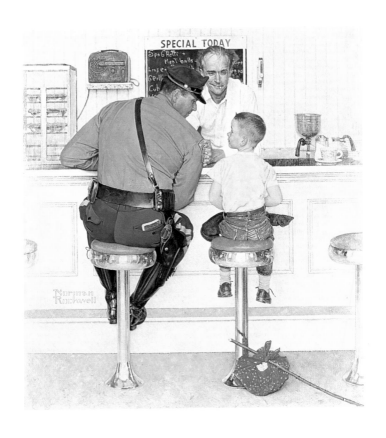

THE RUNAWAY

Saturday Evening Post cover
September 20, 1958

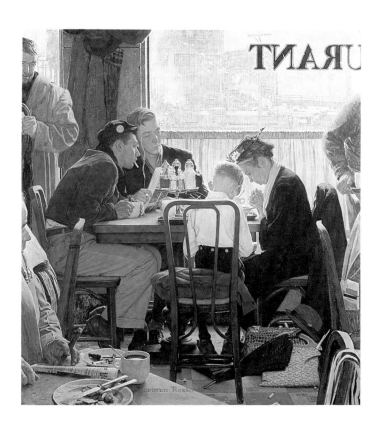

SAYING GRACE

———

Saturday Evening Post cover
November 24, 1951

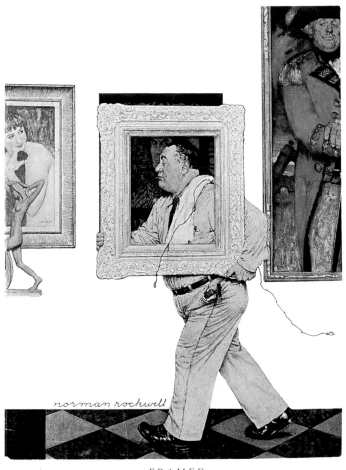

FRAMED

Saturday Evening Post cover
March 2, 1946

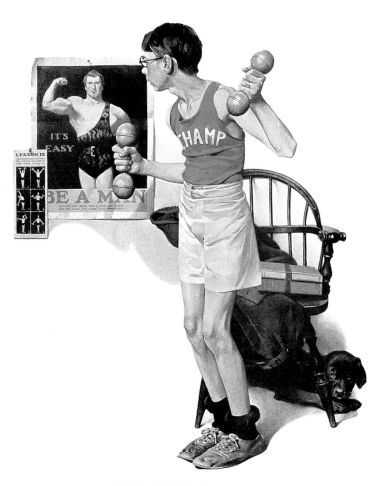

THE BODY BUILDER

Saturday Evening Post cover
April 29, 1922

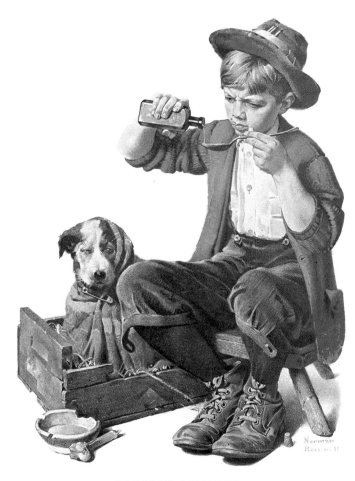

BEDSIDE MANNER

—

Saturday Evening Post cover
March 10, 1923

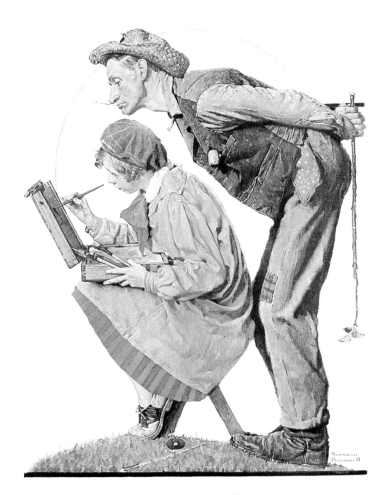

THE CRITIC

———

Saturday Evening Post cover
July 21, 1928

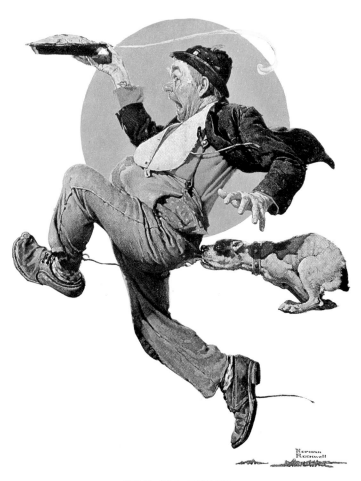

THE PIE THIEF

Saturday Evening Post cover
August 18, 1928

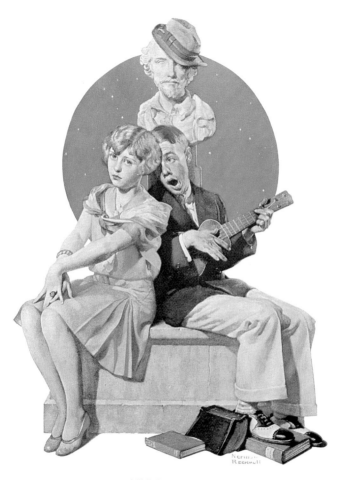

SERENADE

Saturday Evening Post cover
September 22, 1928

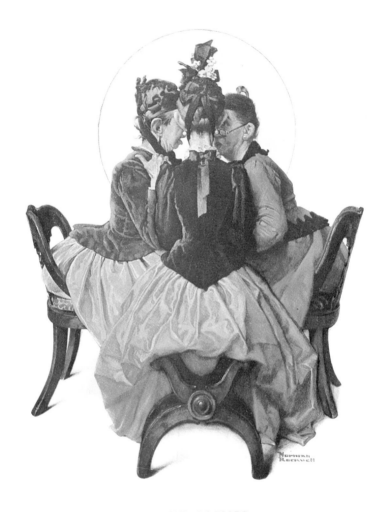

THE GOSSIPS

—

Saturday Evening Post cover
January 12, 1929

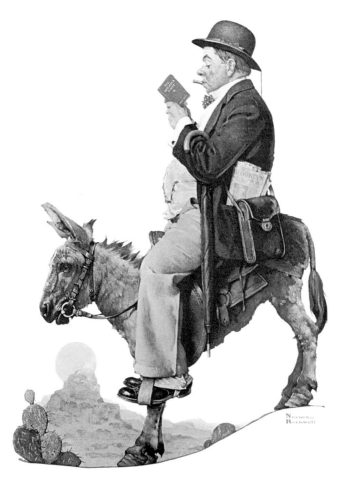

TRAVELER

Saturday Evening Post cover
July 13, 1929

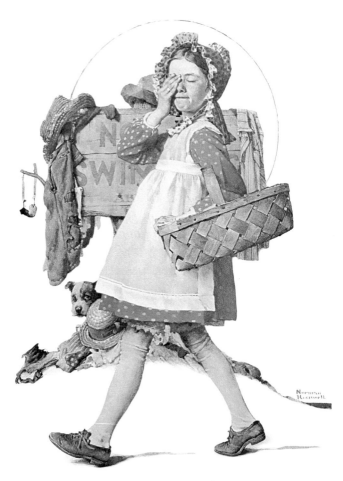

NO SWIMMING

Saturday Evening Post cover
June 15, 1929

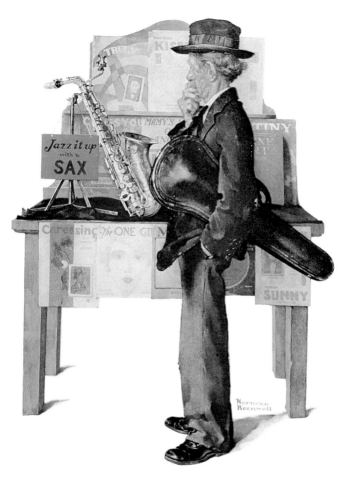

JAZZ IT UP

Saturday Evening Post cover
November 2, 1929

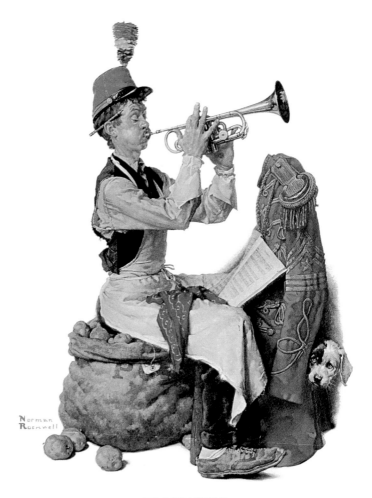

PRACTICING

Saturday Evening Post cover
November 7, 1931

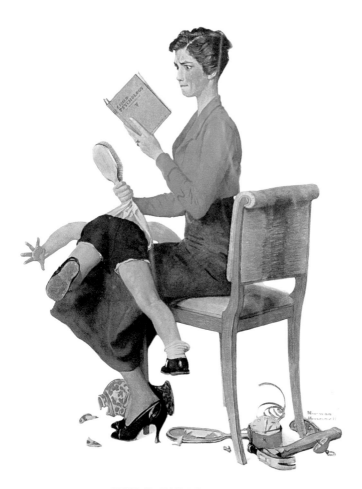

CHILD PSYCHOLOGY
—

Saturday Evening Post cover
November 25, 1933

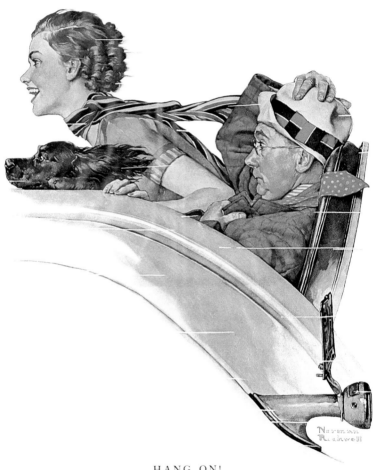

HANG ON!

———

Saturday Evening Post cover
July 13, 1935

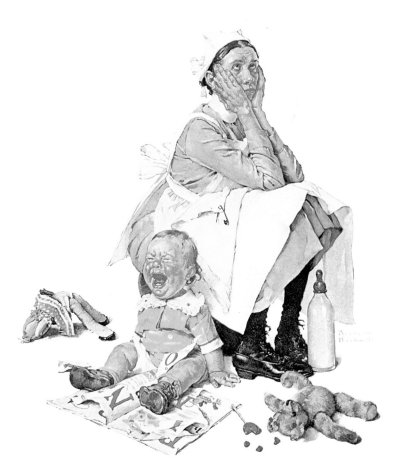

THE NANNY

Saturday Evening Post cover
October 24, 1936

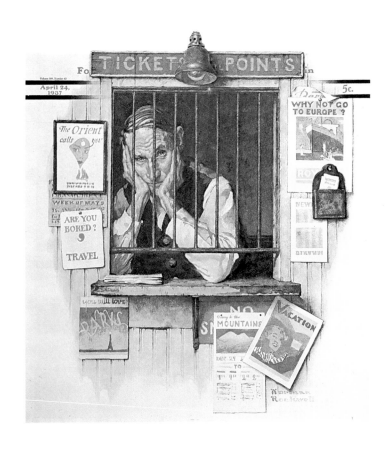

SEE THE WORLD

Saturday Evening Post cover
April 24, 1937

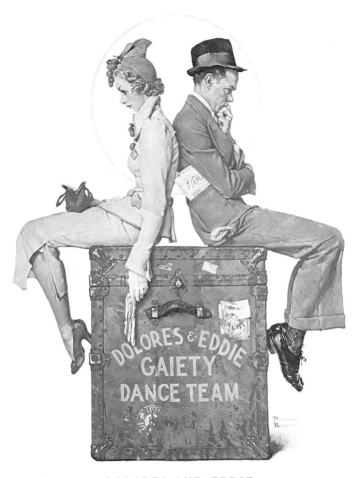

DOLORES AND EDDIE

Saturday Evening Post cover
June 12, 1937

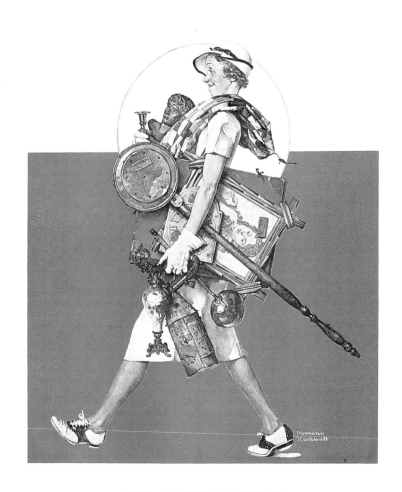

THE ANTIQUE HUNTER

Saturday Evening Post cover
July 31, 1937

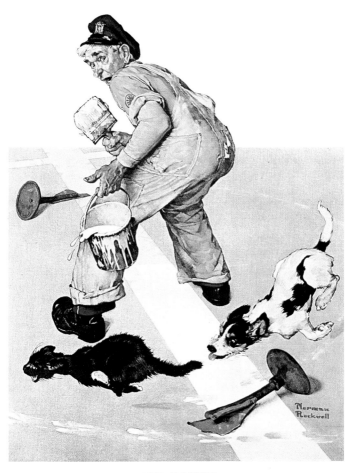

WET PAINT!

———

Saturday Evening Post cover
October 2, 1937

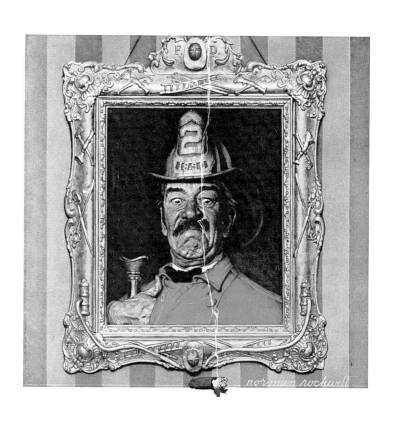

FIRE!

Saturday Evening Post cover
May 27, 1944

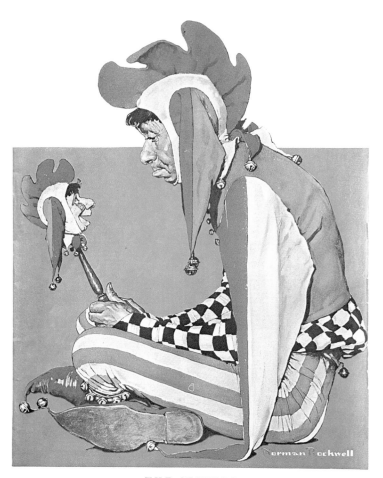

THE JESTERS

Saturday Evening Post cover
February 11, 1939

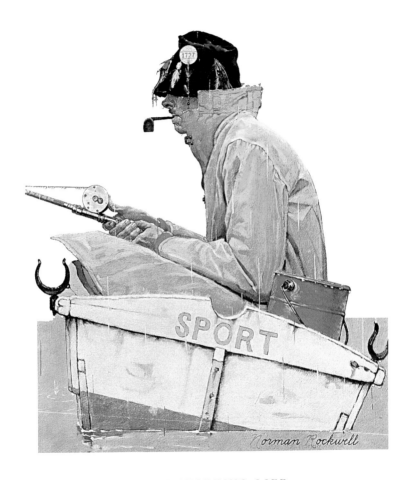

THE SPORTING LIFE

Saturday Evening Post cover
April 29, 1939

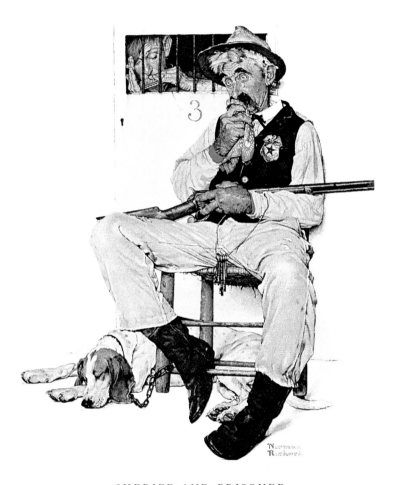

SHERIFF AND PRISONER

Saturday Evening Post cover
November 4, 1939

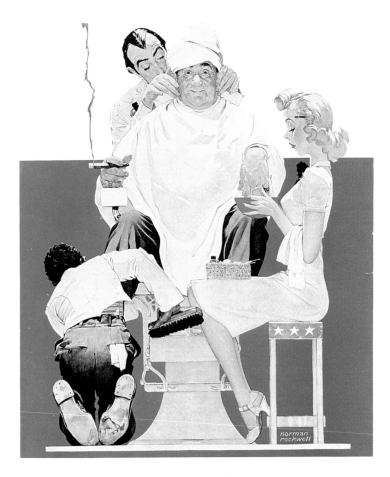

THE WORKS!

Saturday Evening Post cover
May 18, 1940

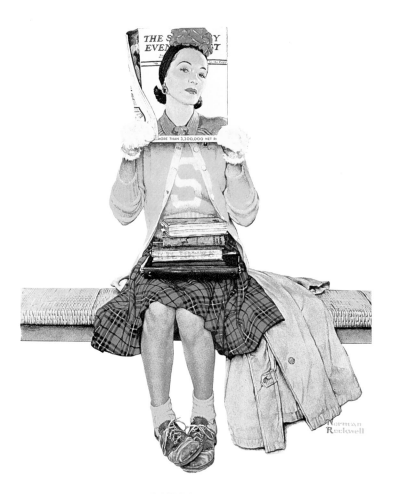

SCHOOLGIRL

—

Saturday Evening Post cover
March 1, 1941

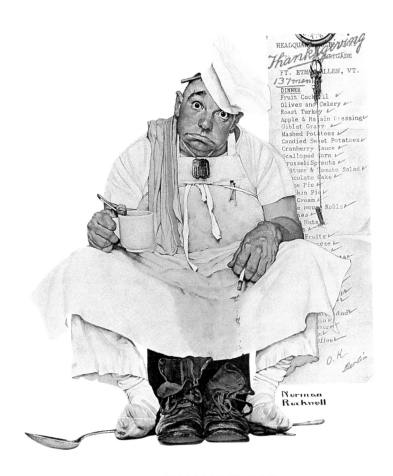

THANKSGIVING DAY

Saturday Evening Post cover
November 28, 1942

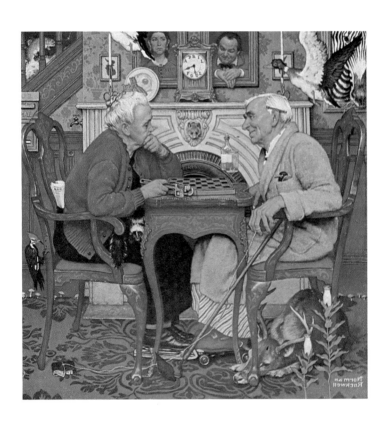

PLAYING CHECKERS

Saturday Evening Post cover
April 3, 1943

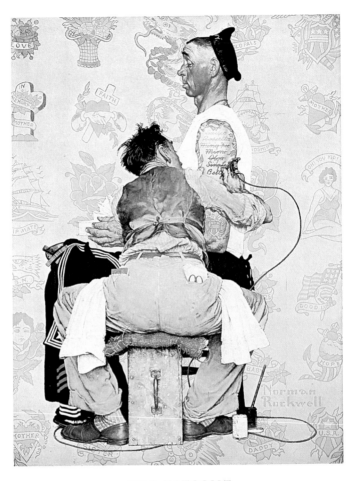

THE TATOOIST

Saturday Evening Post cover
March 4, 1944

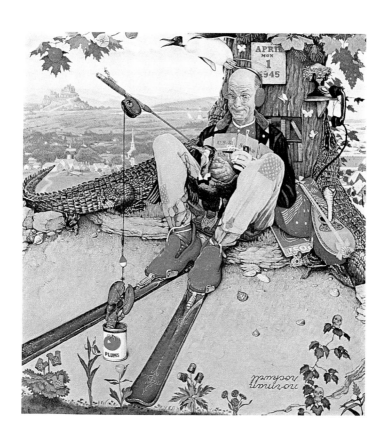

APRIL FOOL'S

—

Saturday Evening Post cover
March 31, 1945

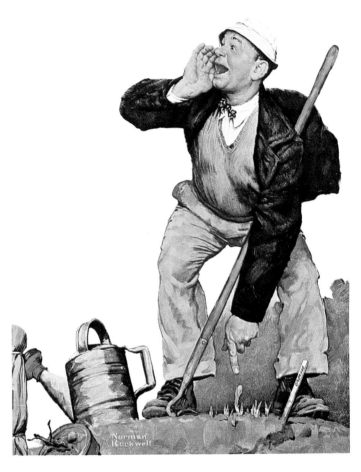

THE HAPPY GARDENER

Saturday Evening Post cover
March 22, 1947

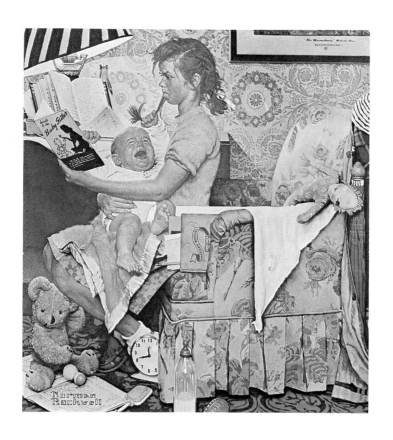

BABYSITTING

Saturday Evening Post cover
November 8, 1947

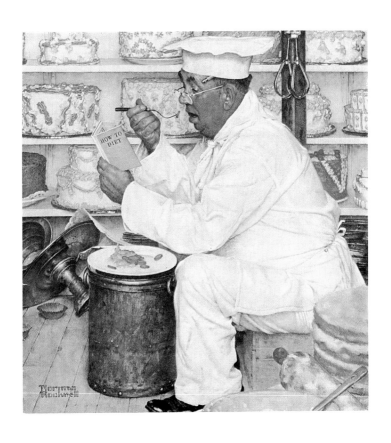

THE DIETER

—

Saturday Evening Post cover
January 3, 1953

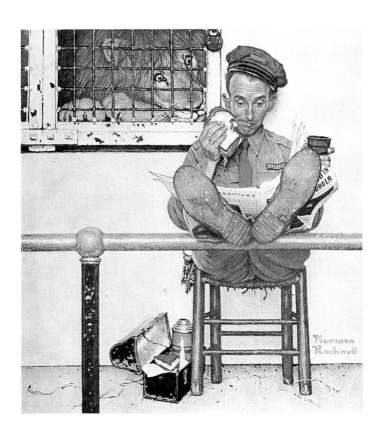

FEEDING TIME

Saturday Evening Post cover
January 9, 1954

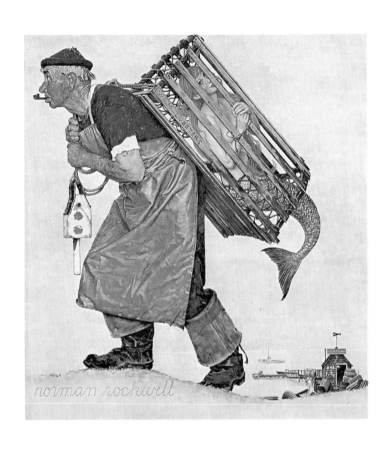

A FAIR CATCH

Saturday Evening Post cover
August 20, 1955

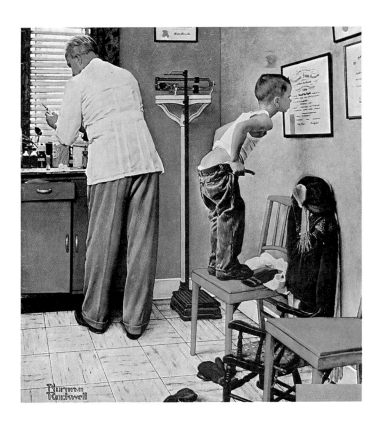

AT THE DOCTOR'S

Saturday Evening Post cover
March 15, 1958

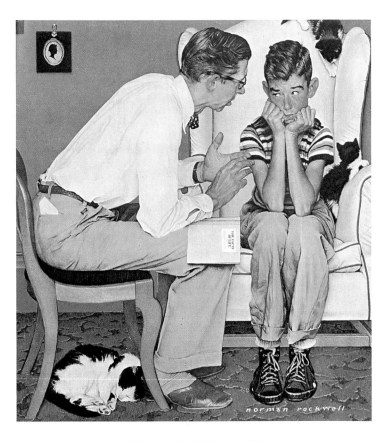

THE FACTS OF LIFE

—

Saturday Evening Post cover
July 14, 1951

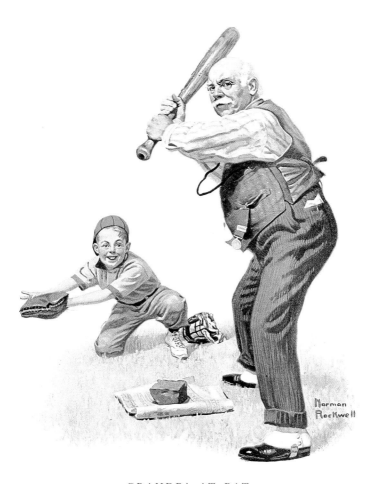

GRANDPA AT BAT

—

Saturday Evening Post cover
August 5, 1916

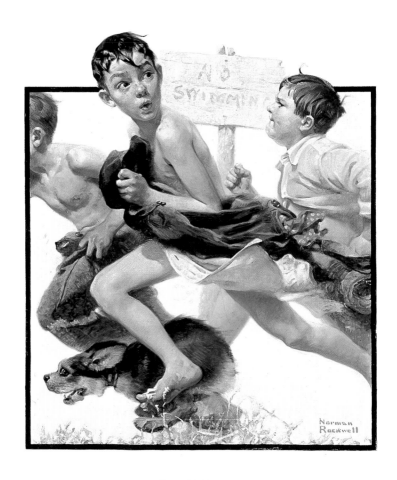

NO SWIMMING

—

Saturday Evening Post cover
June 4, 1921

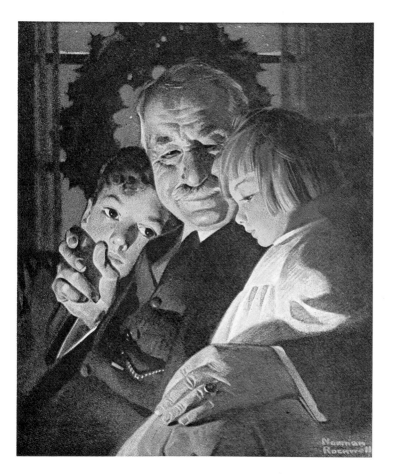

GRANDPA AND CHILDREN

Literary Digest cover
December 24, 1921

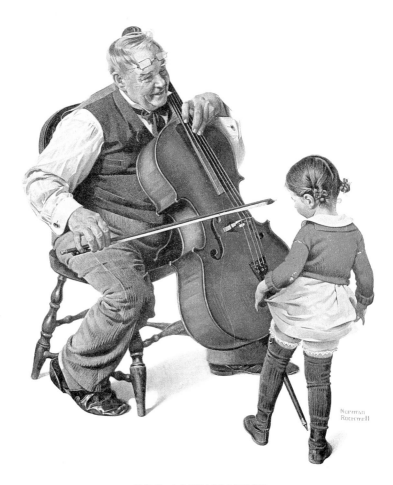

THE ACCOMPANIST

Saturday Evening Post cover
February 3, 1923

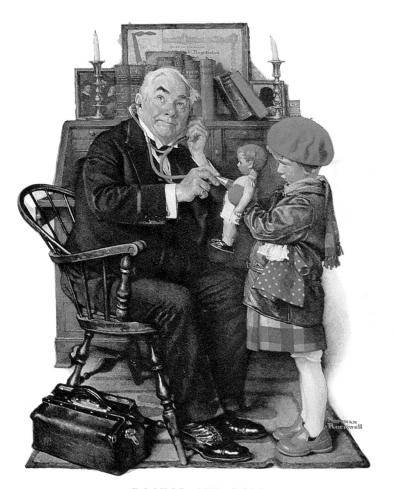

DOCTOR AND DOLL

———

Saturday Evening Post cover
March 9, 1929

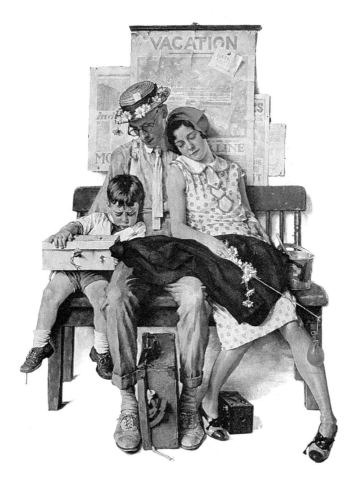

HOME FROM VACATION

Saturday Evening Post cover
September 13, 1930

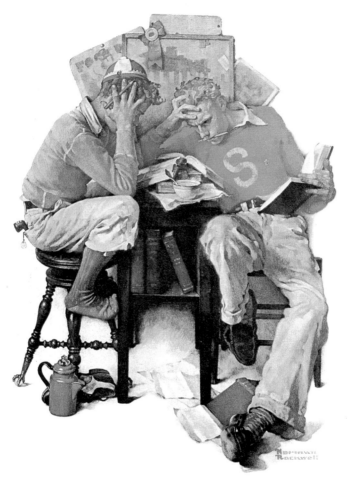

CRAMMING

———

Saturday Evening Post cover
June 13, 1931

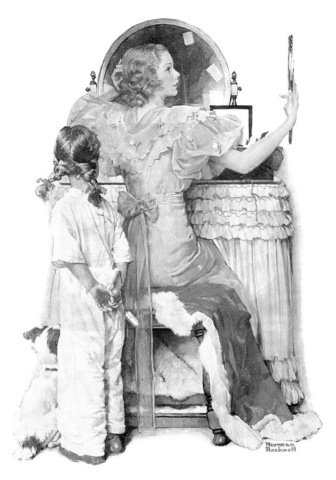

GOING OUT

Saturday Evening Post cover
October 21, 1933

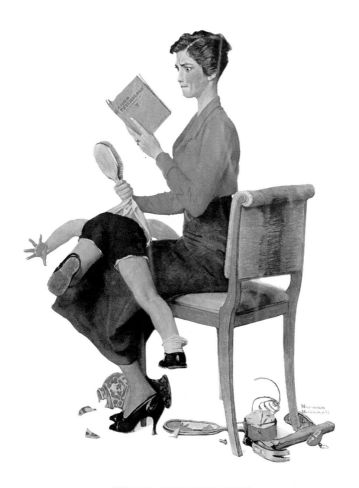

CHILD PSYCHOLOGY

Saturday Evening Post cover
November 25, 1933

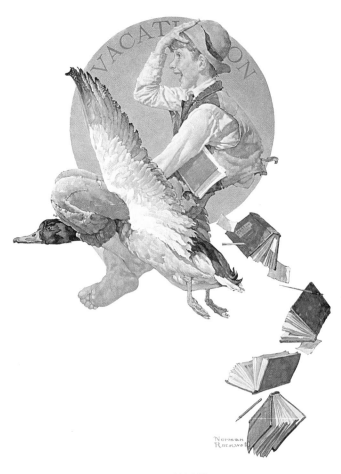

VACATION

Saturday Evening Post cover
June 30, 1934

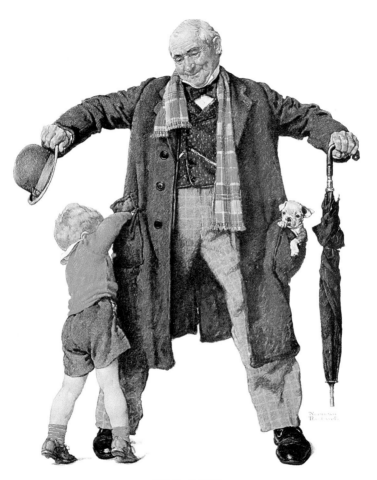

THE GIFT

Saturday Evening Post cover
January 25, 1936

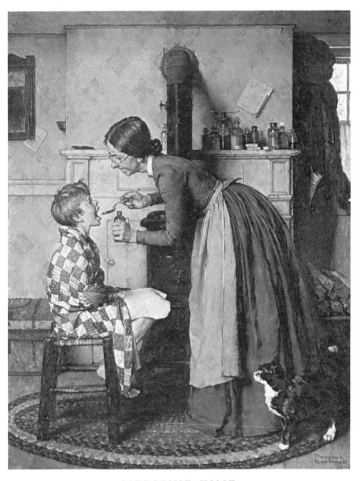

MEDICINE TIME

Saturday Evening Post cover
May 30, 1936

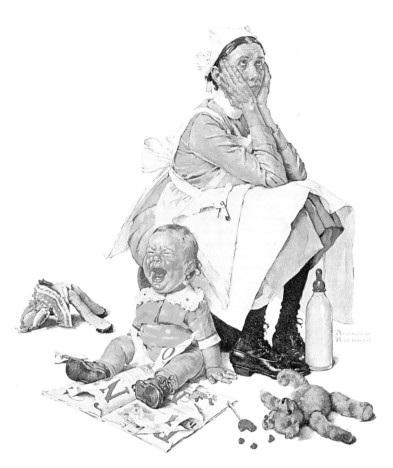

THE NANNY

Saturday Evening Post cover
October 24, 1936

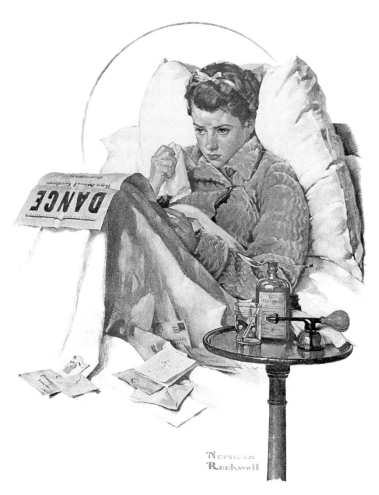

THE COLD

Saturday Evening Post cover
January 23, 1937

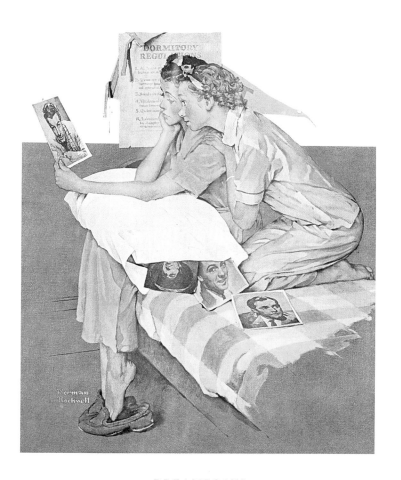

DREAMBOATS

Saturday Evening Post cover
February 19, 1938

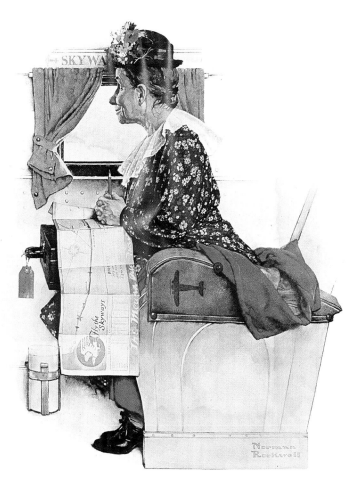

FIRST FLIGHT

Saturday Evening Post cover
June 4, 1938

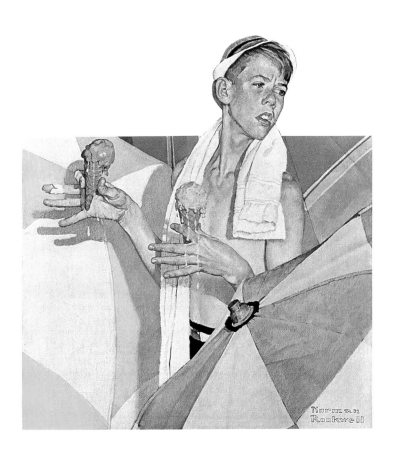

AT THE BEACH

Saturday Evening Post cover
July 13, 1940

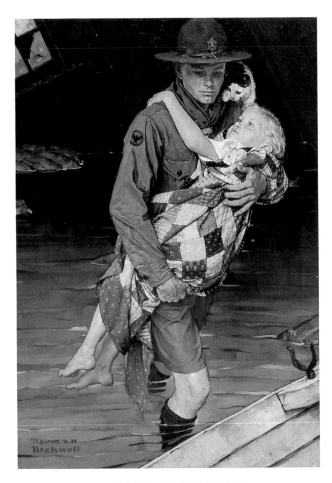

A SCOUT IS HELPFUL

Boy's Life cover
February, 1942

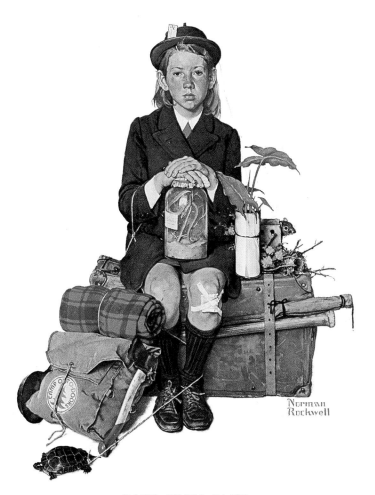

BACK FROM CAMP

—

Saturday Evening Post cover
August 24, 1940

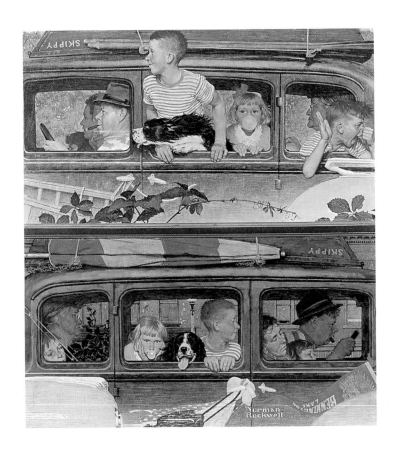

FAMILY OUTING

Saturday Evening Post cover
August 30, 1947

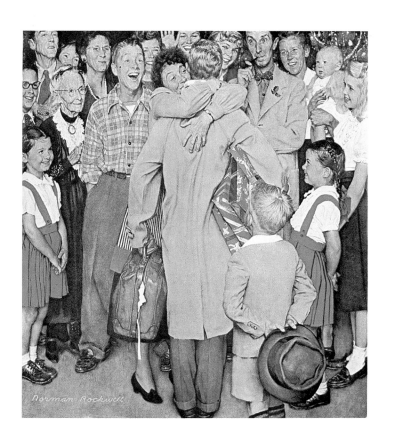

IT'S GOOD TO BE HOME!

———

Saturday Evening Post cover
December 25, 1948

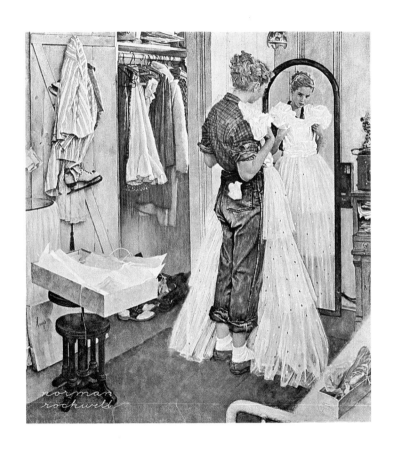

PROM DRESS

Saturday Evening Post cover
March 19, 1949

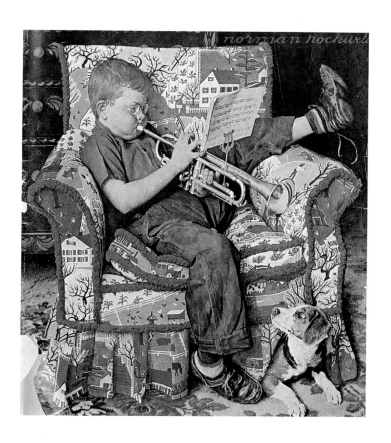

PRACTICE

Saturday Evening Post cover
November 18, 1950

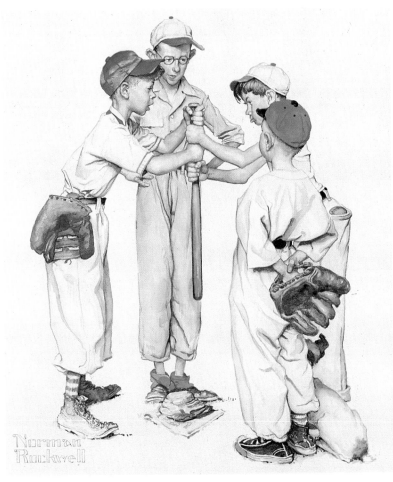

FOUR SPORTING BOYS: BASEBALL

Brown & Bigelow
1951 Four Seasons Calendar, Spring

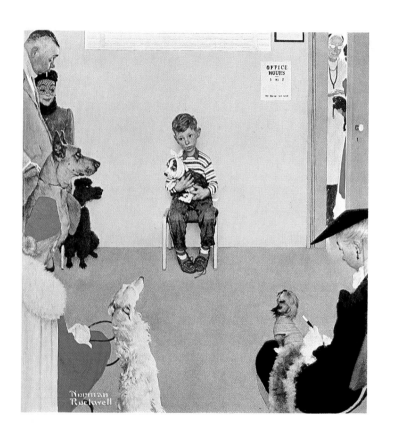

AT THE VET'S

Saturday Evening Post cover
March 29, 1952

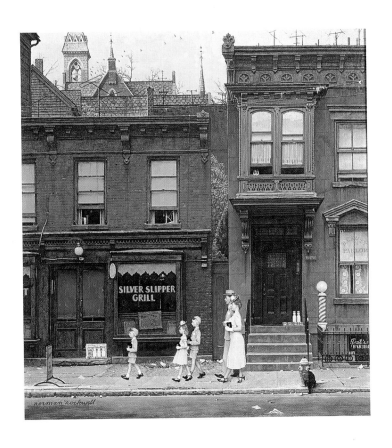

WALKING TO CHURCH

Saturday Evening Post cover
April 4, 1953

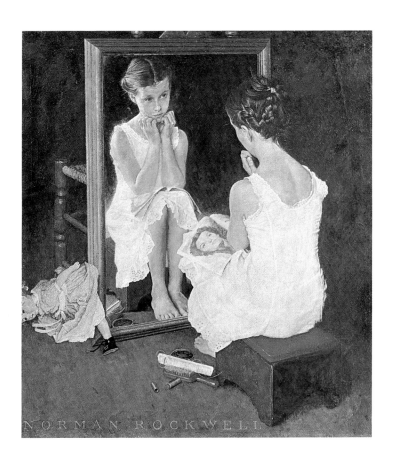

GIRL IN THE MIRROR

Saturday Evening Post cover
March 6, 1954

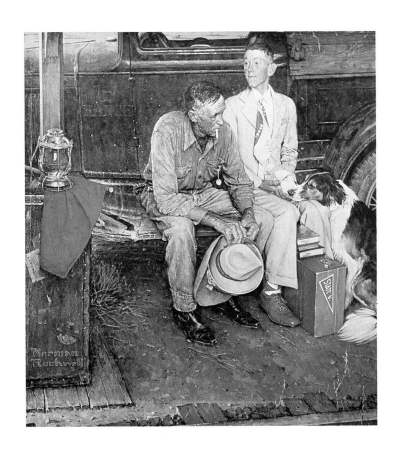

LEAVING HOME

Saturday Evening Post cover
September 25, 1954

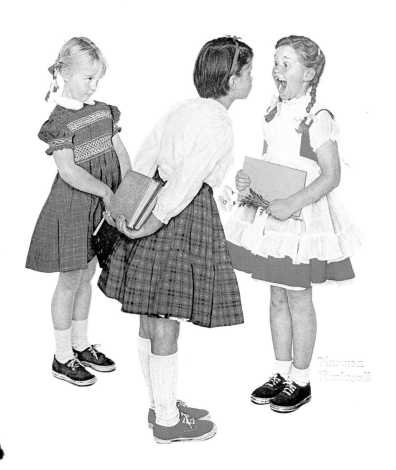

THE LOST TOOTH

Saturday Evening Post cover
September 7, 1957

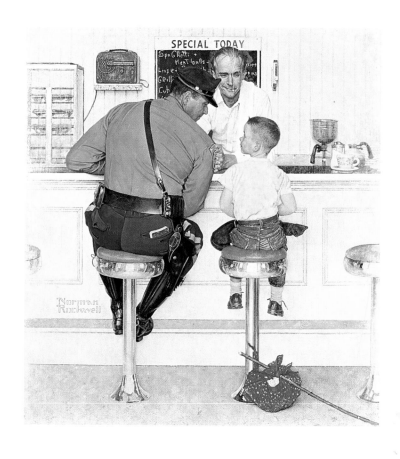

THE RUNAWAY

Saturday Evening Post cover
September 20, 1958

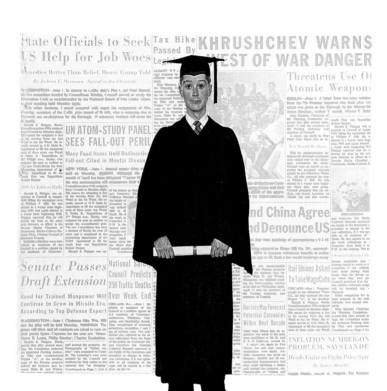

THE GRADUATE

Saturday Evening Post cover
June 6, 1959

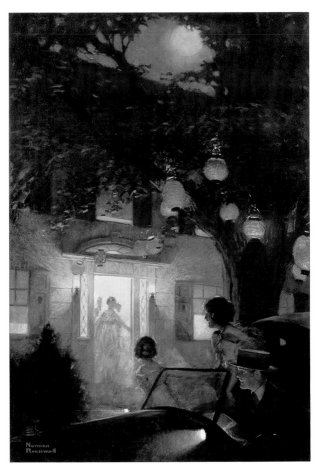

GUESTS ARRIVING AT A PARTY

Saturday Evening Post cover
August 7, 1920

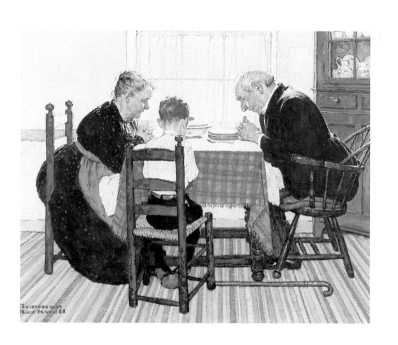

FAMILY GRACE

———

Ladies' Home Journal
August, 1938